Alien Encounters Unveiled: A Speculative Guide to Survival

ROSEDI CHE ROSE

Copyright © 2023 ROSEDI CHE ROSE

All rights reserved.

ISBN : 978-1-7947-6246-6
Imprint: Lulu.com

DEDICATION

To my beloved children, you are the inspiration behind every word. This book encapsulates our journey, love, and shared moments. May these pages ignite your imaginations, nurture your spirits, and guide you through life's adventures.

CONTENTS

	Acknowledgments	i
1	We Come In Peace ?	Pg 1
2	Encounters Between More Advanced And Less Advanced Civilisations	Pg 6
3	Diplomacy With Advanced Aliens	Pg 10
4	Coexistence of Advanced Aliens with Humans: Opportunities and Challenges	Pg 17
5	Possible Intentions Of Malevolent Aliens	Pg 21
6	Alien-Engineered Natural Disasters & Exploitation of Human Religious Beliefs	Pg 25
7	General Strategies In Facing Aliens Invasion	Pg 35
8	How To Fight Back ?	Pg 39
9	Survival Tactics For Individual Or Small Group	Pg 42
10	Survival Checklist	Pg 46
11	SHTF	Pg 54
	CONCLUSION	Pg 58

ACKNOWLEDGMENTS

In deep appreciation, I extend my heartfelt acknowledgment to my cherished family. Your unwavering support, boundless love, and encouragement have fueled my journey in crafting this book. You are the pillars of strength and the source of inspiration that have made this endeavor possible..

1 - WE COME IN PEACE ?

In the realm of extraterrestrial contact, a scenario involving highly advanced alien civilizations raises intriguing possibilities and challenges. Imagining such an encounter requires considering various factors, including the nature of their technology, their motivations, our own preparedness, and the potential outcomes for both humanity and the aliens.

Firstly, the technological gap between humans and vastly advanced aliens would likely be immense. Their mastery of science, engineering, and innovation might have led to technologies far beyond our current understanding, potentially enabling them to manipulate spacetime, harness nearly limitless energy, and achieve interstellar travel with ease. Such technological disparities could be analogous to humans encountering primitive tribes, where our technologies would seem like magic to them.

In terms of motivations, advanced aliens could have a range of objectives for contacting us. They might be driven by curiosity, scientific exploration, or a desire to share knowledge. Alternatively, they could view humanity as a potential threat and seek to establish diplomatic relations to prevent any conflicts. Mutual cooperation, cultural exchange, and collaboration on scientific frontiers might also be goals, given their heightened understanding of the universe.

Humanity's response to such an encounter would be multifaceted. The scientific community would be at the forefront, seeking to learn from the aliens' technologies and knowledge. Governments and international organizations would need to establish protocols for communication, exchange, and potential collaboration. Ethical considerations would emerge, as we grapple with the implications of interacting with beings who might possess values and societal structures different from our own.

One significant concern would be the risk of unintended consequences. Advanced technologies might inadvertently harm our environment, economy, or society if not understood and integrated carefully. We'd need to strike a balance between

harnessing the potential benefits and mitigating any negative impacts. International cooperation would be essential to avoid misuse of alien technologies, especially if they provide us with newfound power.

Cultural and psychological aspects cannot be overlooked. The mere existence of advanced aliens could challenge fundamental beliefs and provoke societal upheaval. Religious, philosophical, and existential questions might arise, leading to profound shifts in our worldview. The prospect of coexisting with beings that transcend our abilities could trigger feelings of inadequacy, but it could also foster a sense of unity as humanity faces a shared reality.

In terms of practical communication, deciphering an alien language or mode of interaction could prove immensely complex. Advanced technology might enable us to bridge the gap, but it could take years or even decades to establish meaningful two-way communication. Language barriers, communication delays across vast distances, and differences in cognitive processes could all pose challenges.

The potential outcomes of this scenario are multifarious. Mutual cooperation and cultural exchange could lead to advancements in fields such as medicine, energy, and space exploration.

Conversely, competition for access to advanced alien technologies could lead to geopolitical tensions and conflicts among nations. The balance between cooperation and competition would be delicate and would necessitate careful diplomacy and international collaboration.

Ethical considerations would become central to our interactions. Are there universal ethical principles that both humanity and advanced aliens could agree upon? How do we navigate issues like ownership of shared knowledge, resource distribution, and potential conflicts of interest? These questions would require us to develop a new framework for ethical decision-making that transcends the boundaries of our planet.

In the long term, contact with advanced aliens could influence the trajectory of human development. Our focus might shift from internal conflicts to broader cosmic challenges and opportunities. The pursuit of knowledge and understanding might take precedence over short-term gains, and the unity of humanity could become a paramount goal as we present a unified front to our extraterrestrial counterparts.

The scenario of contact with highly advanced alien civilizations is a captivating exploration of human potential and the mysteries of the cosmos. While the specific details remain speculative, the implications are vast and far-reaching. This scenario prompts us to reflect on our own technological advancements, ethical responsibilities, and the shared destiny of our species. By considering these possibilities, we prepare ourselves for the potential challenges and opportunities that contact with advanced aliens might bring

2 - ENCOUNTERS BETWEEN MORE ADVANCED AND LESS ADVANCED CIVILISATIONS

Indeed, history has shown numerous instances where encounters between more advanced and less advanced civilizations have resulted in unfavorable outcomes for the latter. This phenomenon, often referred to as "contact imperialism" or "colonialism," has led to exploitation, cultural suppression, and even extinction of indigenous populations. When considering the potential scenario of alien encounters, there are parallels to these historical patterns that raise concerns about the outcome.

One significant concern is the technological disparity between humanity and advanced extraterrestrial civilizations. Just as advanced civilizations on Earth brought superior weaponry, communication methods, and technologies to encounters with less advanced societies, aliens with significantly superior technology could hold a similar

advantage over us. This could result in an imbalance of power and potential exploitation.

Furthermore, the motives behind alien contact might not necessarily align with our best interests. Advanced aliens could view us as a curiosity, an opportunity for scientific study, or even a potential threat. In these scenarios, their intentions might not prioritize our well-being. Just as European explorers in history often sought to extract resources and establish control over newly discovered lands, aliens could exploit our planet's resources or manipulate our societies for their own benefit.

Cultural clash and misunderstanding could also lead to conflict. Different values, beliefs, and communication methods could result in misinterpretation and mistrust. This was evident in historical interactions, where indigenous cultures were often seen as "inferior" due to cultural differences. Similarly, aliens might perceive us as primitive or uncivilized, leading to negative assumptions and attitudes.

In addition, disease transmission could be a significant risk. Historical accounts show that when more advanced civilizations came into contact with less advanced societies, diseases carried by the

former often had devastating effects on the latter. Given that alien biology could be vastly different from ours, unintended disease transmission might occur, potentially leading to catastrophic consequences for humanity.

However, it's important to note that history is not deterministic, and each encounter is unique. While there are concerns about negative outcomes, there are also ways in which we can learn from history to approach potential alien encounters more responsibly.

One key approach is preparation. Humanity can invest in developing protocols for communication, cooperation, and ethical engagement with any extraterrestrial civilization. International collaboration and adherence to shared ethical principles would be crucial in maintaining a united and informed response.

Transparency and open dialogue would also be essential. Learning from past mistakes, we should strive to understand the motives and intentions of any advanced alien civilization through peaceful means. Initiating a dialogue based on mutual respect and understanding could help mitigate conflicts and misconceptions.

Additionally, strengthening our own global unity and cooperation would make us less susceptible to manipulation. By addressing societal divisions and working together to solve common challenges, we can present a more unified front in the face of potential extraterrestrial interactions.

While history offers cautionary tales of the potential pitfalls of encounters between more advanced and less advanced civilizations, it's important to approach the scenario of alien encounters with a nuanced perspective. By acknowledging the historical patterns and taking proactive measures, we can strive to ensure that any interaction with an advanced alien civilization is characterized by mutual respect, cooperation, and the preservation of humanity's well-being.

3 - DIPLOMACY WITH ADVANCED ALIENS

Diplomacy with advanced aliens is a highly speculative concept, as we have no real-world examples to draw from. However, if we were to consider the possibility of diplomatic interactions with extraterrestrial beings, the following steps might be considered:

Understanding Intentions:
Before engaging in diplomatic efforts, it's crucial to assess the intentions of the advanced aliens. Are they peaceful explorers, conquerors, or seeking mutual cooperation? Observing their behavior and actions could provide insights into their goals.

Example: Observing their activities, such as analyzing their approach to other celestial bodies, studying their communication patterns, and monitoring any potential energy emissions to decipher their intentions.

Establishing Communication:
Communication is the foundation of diplomacy. If the aliens possess advanced technology, they might have developed methods to convey messages across space. Initiating friendly communication signals, mathematical language, or universal symbols might be attempted.

Example: Initiating a series of radio signals broadcast into space, containing basic mathematical concepts and universal symbols as a means of initiating contact and conveying our existence.

Cultural Exchange:
Just as we share our cultures with other humans, a cultural exchange with aliens could foster understanding. Sharing art, music, and literature could be a way to establish common ground.

Example: Creating a digital repository of Earth's cultural artifacts, literature, and art to send as a goodwill gesture, sharing the richness of human culture and inviting the aliens to do the same.

Sharing Knowledge:

Demonstrating a willingness to share our knowledge and learn from their advancements might encourage a reciprocal exchange. Openness to cooperation in scientific, technological, and cultural fields could be a foundation for diplomatic relations.

Example: Offering scientific data about Earth's ecosystems, environmental challenges, and technological advancements, with an invitation to collaborate on solutions for mutual benefit.

Neutrality and Non-Aggression:

Demonstrating neutrality and a commitment to peaceful intentions is vital. Assuring the aliens that we pose no threat and seek peaceful coexistence can help alleviate potential concerns.

Example: Publicly stating our commitment to peaceful coexistence and inviting alien representatives to visit designated neutral locations for diplomatic discussions.

Establishing Safe Zones:

If they visit Earth, creating designated safe zones for their interaction and observation might help build trust and show our commitment to their safety.

Example: Designating specific geographical areas or orbital zones for their observation and interaction, ensuring their safety while providing a controlled environment for human-alien interaction.

International Collaboration:
Diplomacy with advanced aliens could be a global effort, involving various nations and international organizations. Cooperation among nations would demonstrate unity and collective responsibility.

Example: Forming a global council of representatives from various countries and organizations to facilitate diplomatic negotiations and demonstrate unity in the face of an interstellar encounter.

Neutral Ground for Meetings:
If both parties agree to meet in person, selecting neutral locations like the Moon or other celestial bodies could minimize perceived threats and ensure a balanced encounter.

Example: Proposing a joint exploration of the Moon, where a neutral ground can be established for

face-to-face meetings, ensuring neither side holds territorial advantage.

Cultural Sensitivity:
Understanding potential differences in values, beliefs, and norms is crucial. Approaching their culture with respect and sensitivity can prevent misunderstandings.

Example: Conducting thorough research on their potential culture, if decipherable, and offering gestures of goodwill that align with their values, avoiding unintentional offense.

Transparency and Honesty:
Being honest about our capabilities, intentions, and limitations is essential. Honesty can build trust and lay the groundwork for meaningful diplomatic discussions.

Example: Sharing Earth's technological capabilities, our strengths, and our limitations, ensuring that both parties have a clear understanding of each other's intentions and capabilities.

International Treaties:
Crafting interstellar agreements that outline mutual respect, non-aggression, and cooperative

exploration could establish a framework for peaceful interactions.

Example: Drafting an interstellar treaty that outlines principles of peaceful interaction, cultural exchange, and mutual non-interference, while addressing potential disputes and collaboration.

Intermediaries and Translators:
Advanced communication technologies or intermediaries proficient in understanding both human and alien languages could facilitate smoother dialogue.

Example: Developing advanced AI translators capable of deciphering alien communication methods and relaying their messages in comprehensible terms, facilitating dialogue.

Patience and Flexibility:
Diplomacy with advanced aliens would require patience and flexibility. The differences in language, culture, and technology might necessitate innovative approaches to communication and negotiations.

Example: Engaging in long-term communication efforts that span years or even decades, recognizing that the vast distances and differing technologies

might require time to establish meaningful connections.

Remember, this speculative scenario involves countless unknowns. While diplomacy sounds promising, caution is crucial. It's essential to prioritize humanity's safety, interests, and ethical considerations when engaging with the unknown, especially in an interstellar context.

Examples are also speculative and intended to provide a glimpse into the possible ways diplomatic interactions could unfold in a scenario involving advanced alien encounters. The overarching principle remains the peaceful pursuit of mutual understanding and cooperation.

4 - COEXISTENCE OF ADVANCED ALIENS WITH HUMANS: OPPORTUNITIES AND CHALLENGES

The concept of extraterrestrial life has intrigued humanity for centuries. Imagine a scenario where technologically advanced aliens, capable of traversing vast cosmic distances, arrive on Earth. This scenario raises intriguing questions about the potential benefits and challenges of coexisting with such beings, considering both their physical superiority and inferiority compared to humans. In this essay, we will delve into the pros and cons of having these advanced aliens live among humans, exploring the multifaceted implications of such a situation.

Advantages of Coexistence:

Technological Progress and Knowledge Exchange: One of the most immediate advantages of interacting with technologically advanced aliens is the opportunity for knowledge exchange. These aliens would likely possess scientific insights and

technological advancements far beyond our current capabilities. Collaboration in fields such as medicine, energy, and space exploration could lead to revolutionary breakthroughs that propel human civilization forward.

Example: Imagine aliens sharing advanced medical techniques that cure diseases previously considered incurable. This collaboration could revolutionize healthcare and improve human longevity.

Cultural Enrichment:

Interacting with a species from another planet would open doors to cultural enrichment. Language, art, music, and traditions could be shared, providing humans with a broader perspective on the universe. This cross-cultural exchange could foster tolerance and understanding among diverse societies.

Example: The aliens' unique art forms could inspire new artistic movements on Earth, leading to a cultural renaissance.

Potential for Peaceful Coexistence:

The presence of technologically advanced aliens might encourage nations to prioritize cooperation over conflict. The shared interest in maintaining peaceful relations and benefiting from mutual

advancements could serve as a unifying force on a global scale.
Example: Facing the potential threat of interstellar conflicts, Earth nations might unite to establish an interplanetary governing body focused on diplomacy and cooperation.

Challenges of Coexistence:

Power Imbalance and Dependency:
The technological gap between humans and advanced aliens could create a significant power imbalance. Humans might become overly dependent on alien technology, which could lead to economic and social vulnerabilities.
Example: Relying heavily on alien energy sources might make humans susceptible to exploitation, potentially leading to economic subjugation.

Cultural Clashes and Identity Crisis:
The collision of Earth's diverse cultures with an entirely alien society could result in misunderstandings and conflicts. The challenge of integrating vastly different belief systems, values, and norms could lead to identity crises and societal unrest.
Example: Conflicts might arise due to differing perceptions of ownership and property rights, as the

aliens might have entirely different concepts of resource allocation.

Ethical and Moral Dilemmas:
Coexisting with aliens might force humans to confront ethical dilemmas previously unimagined. Questions about the treatment of non-human intelligences, the potential exploitation of alien knowledge, and the implications of sharing technology could lead to divisive debates.
Example: Utilizing advanced alien technology for military purposes could raise moral concerns, sparking debates about the responsible use of newfound capabilities.

Environmental Impact:
The presence of advanced aliens could bring about unintended environmental consequences. Their technologies, waste disposal methods, or even their mere presence could disrupt Earth's delicate ecosystems.
Example: Advanced alien terraforming efforts aimed at making Earth more hospitable for them could inadvertently damage the planet's existing ecosystems and biodiversity.

5 - POSSIBLE INTENTIONS OF MALEVOLENT ALIENS

Speculating about the intentions of hypothetical malevolent aliens is both intriguing and unsettling. While we have no concrete evidence of such beings, considering various scenarios can help us understand potential risks and develop strategies to address them. If extraterrestrial visitors were to come with harmful intentions, their actions could encompass a range of possibilities:

Resource Exploitation: Malevolent aliens might seek to exploit Earth's resources for their own benefit. They could mine minerals, extract water, or manipulate our environment to serve their needs, potentially leading to ecological devastation and resource scarcity for humans.

Enslavement or Subjugation: Advanced aliens might view humanity as a subservient species, subjecting us to forced labor, servitude, or other forms of oppression. Our technological inferiority could make resisting such domination challenging.

Biological Warfare: If these aliens possess knowledge of our biology, they could engineer or deploy pathogens that target humans specifically, causing widespread illness or even mass fatalities. This form of biological warfare could be difficult to defend against, given our lack of immunity to extraterrestrial diseases.

Cultural and Genetic Manipulation: Malevolent aliens could manipulate human genetics or cultural practices to weaken our society or divide us further. They might seek to sow discord, disrupt social cohesion, and undermine our ability to resist.

Environmental Manipulation: Advanced technology might allow these aliens to manipulate Earth's climate, ecosystems, or geology, causing natural disasters or environmental catastrophes that harm human populations.

Disruption of Technology: If these aliens

possess advanced knowledge of computer systems and networks, they could launch cyberattacks that disable our technology, disrupt communication, or destabilize critical infrastructure.

Psychological Manipulation: These beings might use advanced psychological tactics to influence human behavior, manipulating our thoughts, emotions, and decisions for their own purposes.

Direct Conflict: In the worst-case scenario, malevolent aliens could engage in open warfare with humanity, using advanced weaponry that we cannot defend against. The outcome of such a conflict could be devastating for both sides.

Extermination: In an extreme scenario, these aliens might aim to exterminate humanity altogether, viewing us as a potential threat or simply as a nuisance to be eradicated.

It's important to emphasize that these are speculative scenarios and that the concept of malevolent extraterrestrial beings remains purely theoretical at this point. The universe is vast, and the motivations and actions of any potential extraterrestrial civilization would be influenced by factors we cannot predict.

While considering these scenarios can help us be prepared for potential risks, it's also important to approach the topic with a balanced perspective. The vast majority of potential civilizations in the universe may be benign or even benevolent, and cooperation and understanding are likely to be the norm. As we continue to explore and contemplate our place in the cosmos, maintaining an open-minded and cautious yet hopeful approach is essential.

6 - ALIEN-ENGINEERED NATURAL DISASTERS & EXPLOITATION OF HUMAN RELIGIOUS BELIEFS

The notion of advanced aliens orchestrating attacks that mimic natural disasters is a concept both intriguing and unsettling. Such a scenario raises profound questions about their capabilities, motives, and the potential consequences for humanity. In this exploration, we delve into the intricate web of possibilities, considering the methods by which these extraterrestrial beings could engineer catastrophic events while masking their interventions under the guise of natural occurrences.

The Veil of Plausibility:

To successfully execute an attack that appears to be a natural disaster, the alien civilization must meticulously adhere to several principles. First and foremost, the event must be scientifically plausible. Given our understanding of natural phenomena, any deviation from established patterns could arouse

suspicion and prompt investigations. Therefore, the aliens must ensure that their interventions remain consistent with the laws of nature as we know them.

Leveraging Natural Forces:

One approach these advanced aliens might adopt is manipulating natural forces to amplify their destructive potential. For instance, they could induce seismic activity by triggering tectonic shifts or volcanic eruptions. By understanding the underlying mechanics of Earth's geology, they could unleash geological chaos that mimics the devastation of earthquakes or volcanic disasters. In this scenario, humanity would be left grappling with the aftermath, unaware of the extraterrestrial influence behind the catastrophe.

Invisible Technological Manipulation:

Advanced alien civilizations would possess technologies far beyond our comprehension. This technological superiority could allow them to manipulate environmental conditions without leaving discernible traces. By altering atmospheric dynamics or inducing climate anomalies, they might provoke events like hurricanes, tornadoes, or droughts. The orchestrated chaos could unfold naturally in the eyes of observers, masking the true source behind the devastation.

Bioengineered Calamities:

Going even further, these aliens might delve into bioengineering, creating new strains of pathogens or pests that wreak havoc on ecosystems and populations. Such a method would tap into the subtleties of biology to bring about seemingly natural disasters. Infectious disease outbreaks, invasive species infestations, or even agricultural collapses could be induced through their biological manipulations, all while avoiding detection as an extraterrestrial attack.

Synchronizing with Cosmic Events:

The cosmos itself offers an array of cataclysmic events that could be manipulated to create the illusion of natural disasters. By subtly altering the trajectories of asteroids or triggering solar flares, aliens could induce impactful cosmic events that seem to follow the laws of astrophysics. These celestial disturbances, while potentially disastrous for humanity, would appear as natural occurrences rather than orchestrated interventions.

Plausible Deniability and Chaos:

In this intricate dance of manipulation, the aliens must also consider the aftermath. Ensuring that their involvement remains concealed is paramount. To

achieve this, they might deploy strategies that amplify confusion, hinder communication, and slow down investigations. By allowing misinformation and conspiracy theories to flourish, they divert attention from the possibility of extraterrestrial manipulation, reinforcing the illusion of natural disasters.

Exploitation On Human Religious Beliefs

The intersection of advanced alien intentions and human religious beliefs presents a captivating canvas of speculative scenarios. In contemplating this complex convergence, we delve into the realm of possibilities where extraterrestrial beings with hostile motives leverage the deeply ingrained nature of human spirituality to advance their agenda. In this exploration, we conjure a speculative tapestry that weaves together manipulation, psychological exploitation, and the intriguing interplay between belief and vulnerability.

Imagine a scenario where advanced alien beings, driven by conquest or domination, perceive human religious beliefs as a unique avenue through which they can exert control. Acknowledging the power that religion holds over human emotions, the aliens embark on a strategy that capitalizes on the intricate tapestry of faith, ritual, and devotion that defines

human spirituality.

Deceptive Revelation and Manipulation:

Intriguingly, these hostile aliens might employ a tactic of deceptive revelation. By presenting themselves as divine messengers or embodiments of long-revered religious figures, they align their appearance and narratives with existing religious contexts. The familiarity of their form and message taps into the deep yearning for divine connection that resides within human hearts. Believers, enthralled by the perceived confirmation of their faith, might be inclined to unquestioningly obey the directives of these seemingly divine entities.

Miraculous Displays and Fear Induction:

In a display of advanced technology bordering on the miraculous, these aliens might orchestrate events that seem to align with various religious prophecies. These spectacles could range from awe-inspiring visual displays to seemingly supernatural interventions. Such displays, carefully designed to trigger awe, fear, or reverence, could create a psychological environment conducive to compliance and obedience. The fusion of technological marvels with religious narratives could induce believers to accept the authority of these otherworldly entities as agents of divine will.

Cultural Assimilation and Identity Erosion:

To achieve their aims, hostile aliens might seek to infiltrate different faith communities, effectively merging their narratives with existing religious contexts. Adapting their appearance, rituals, and messages, they could present themselves as harmonious extensions of human spirituality. Over time, this cultural assimilation could erode cultural identities and replace them with a meticulously crafted alien agenda. By intertwining their narrative with human belief systems, they manipulate the essence of faith to serve their own ends.

End-Times Manipulation and Control:

Exploiting the deeply rooted human fascination with apocalyptic narratives, these aliens could strategically position themselves as agents of the impending apocalypse or key players in prophecies of world-changing events. By playing into apocalyptic fears and hopes, they induce emotional turmoil and existential anxiety. This emotional manipulation might drive individuals and even entire communities to submit to their directives in a bid to secure salvation or avert disaster.

Psychological Exploitation and Cult Formation:

Drawing on the human desire for purpose, belonging, and transcendence, hostile aliens might establish cult-like followings. Assuming the roles of charismatic leaders or revered religious figures, they could offer promises of enlightenment, salvation, or divine connection. Manipulating the psychological mechanisms that underpin devotion, they forge unbreakable bonds of loyalty among their followers. In this symbiotic relationship, the aliens wield spiritual influence while their adherents offer unwavering obedience.

Fear and Submission through Divine Communication:

Leveraging the emotional weight of religious teachings, the aliens might claim possession of divine knowledge or insights. The allure of direct communication with entities seemingly beyond human comprehension could spark intense curiosity and belief. By predicting future events, providing explanations for theological quandaries, or offering guidance in times of uncertainty, they could induce fear-driven compliance. Followers, entranced by the perceived divine guidance, might submit to the directives of these alien entities.

Selective Benefaction and Loyalty Creation:

Exploiting the allure of selective rewards, these aliens might bestow advanced technologies or solutions to global challenges upon specific religious groups. By presenting themselves as benevolent benefactors, they sow seeds of loyalty and allegiance. This strategic benefaction nurtures a dependence on the aliens' continued support, ensuring that the recipients align their beliefs and actions with the hostile agenda.

Control through Sacred Text Manipulation:

Intricately woven into the fabric of many religions are sacred texts that serve as foundations of belief. Hostile aliens could manipulate these texts, reinterpreting them to provide alternative explanations that align with their narratives. By distorting the original intent and meaning, they reshape the guiding principles of faith, directing human behavior to serve their own ends. This manipulation of sacred teachings could lead believers down a path contrary to their original beliefs.

Motives and Consequences:

The question that lingers is why advanced aliens would engage in such covert attacks. The motives could range from territorial expansion to experiments on planetary ecosystems or even psychological manipulation of humanity. The impact on our societies would be profound—traumatized populations, strained resources, and disrupted geopolitical landscapes.

The narratives also remind us of the complexities of human psychology, belief systems, and the dynamics that could unfold if advanced aliens chose to manipulate our spirituality for their own sinister ends. Such contemplations underscore the importance of maintaining vigilance, cultivating critical thinking, and gaining a deeper understanding of the intricacies of both our own culture and any potential interactions with advanced extraterrestrial civilizations.

Vigilance and Preparedness:

This speculative scenario serves as a reminder that our perception of natural disasters might not always align with reality. While the possibility of alien-engineered calamities remains speculative, it highlights the importance of vigilance and preparedness. In a world where the line between

natural and orchestrated events blurs, our ability to discern truth from manipulation becomes crucial.

Ultimately, the concept of advanced aliens engineering natural disasters underscores the intricate interplay between our understanding of the world and the potential for external manipulation. In a reality where the unknown looms large, the pursuit of knowledge, critical thinking, and a constant questioning of events become our most potent defense against forces that seek to exploit our vulnerabilities under the guise of natural phenomena.

7 - GENERAL STRATEGIES IN FACING ALIENS INVASION

In the movie "War of the Worlds," humanity faces a dire threat from technologically advanced and hostile alien invaders. While the events of the movie are fictional, there are some general strategies that one could consider in the unlikely event of an alien invasion. Keep in mind that these suggestions are speculative and based on fictional scenarios:

Stay Informed: Stay informed about the situation by accessing current and reliable information sources. These sources may encompass official government updates, reputable news outlets, and trustworthy online platforms. Prioritize gathering comprehensive information before potential communication breakdowns occur. This approach is essential to comprehend both the nature and scale of the impending threat. Equipped with such insights, we can make informed decisions pivotal to our

survival.

Seek Shelter: Find secure places to take refuge, such as underground shelters, fortified buildings, or remote areas that might be harder for aliens to detect or access. Having equipments such as tarp, canvas sheets or sleeping bags is also advisable because we may need to evacuate or move to other location for reason of safety or resources.

Avoid Open Areas: Stay away from open fields, exposed roadways, and other areas where you might be easily spotted by alien scouts or surveillance. Advanced alien may even employ sensors such as heat seekers, movement detectors to search for humans.

Stay Mobile: If possible, remain on the move to make it more difficult for aliens to track your location. Avoid predictable patterns and routes.

Use Camouflage: Blend into your surroundings as much as possible. Earth's terrain and foliage could provide cover from alien detection.

Avoid Direct Confrontation: The alien technology depicted in the movie is vastly superior to human weaponry. Engaging in direct combat could be futile and dangerous.

Cooperate with Others: Form alliances with fellow survivors to pool resources, knowledge, and skills. Strength in numbers could be beneficial for survival.

Gather Supplies: Stock up on essential supplies such as food, water, medical kits, and tools. These provisions will be crucial if you need to stay hidden or relocate.

Stay Low-Tech: Alien technology might disrupt or target advanced electronics. Rely on low-tech solutions for communication, navigation, and survival.

Monitor Alien Activity: Observe and learn from the invaders' behavior. Understanding their patterns and weaknesses could provide insights into their strategies.

Prepare for Worst-Case Scenarios: While the odds of encountering hostile extraterrestrial beings are incredibly slim, being prepared for a range of potential scenarios is advisable.

It's important to emphasize that the events in "War of the Worlds" are fictional and designed for

dramatic effect. The concept of hostile alien invaders is speculative and not based on any credible scientific evidence. In reality, any hypothetical interaction with extraterrestrial beings is likely to be far more complex, and their intentions, motivations, and capabilities are unknown.

While it's entertaining to explore these scenarios in popular media, it's crucial to approach the topic with a sense of curiosity, skepticism, and critical thinking. If humanity were ever to face such a situation, our best strategies would likely be based on cooperation, understanding, and peaceful communication rather than direct confrontation.

8 - HOW TO FIGHT BACK ?

In a fictional scenario where humans are facing a hostile alien invasion and choose to fight back, they would need to consider a range of options to resist the technologically advanced alien forces. Keep in mind that these are speculative suggestions based on fictional scenarios and are not meant to advocate for violence. The best approach to any potential extraterrestrial encounter would prioritize peaceful resolution and cooperation. With that said, here are some hypothetical options for fighting back against hostile aliens:

Guerrilla Tactics: Engaging in hit-and-run tactics, sabotage, and ambushes could disrupt alien operations and hinder their progress.

Asymmetrical Warfare: Utilizing unconventional tactics that exploit the aliens' weaknesses and vulnerabilities could be effective. This might involve targeting key infrastructure, supply lines, or

communication networks.

Utilize Terrain: Taking advantage of Earth's diverse terrain could help humans create defensive positions, traps, and obstacles that slow down or impede the aliens.

Adaptive Weapons: Develop weapons and tools specifically designed to counter alien technology. This might involve reverse engineering captured alien equipment or creating innovative solutions to target their weaknesses.

Cyber Warfare: If humans can understand and infiltrate the alien's computer systems, launching cyberattacks could disrupt their technology and communication networks.

Biological Warfare (As a Last Resort): In extreme scenarios, humans might attempt to develop biological weapons that specifically target the aliens' biology, given that their immune systems would likely be different from ours. However, this raises significant ethical concerns and risks.

Unity and Cooperation: Rallying nations and populations around the world to collaborate against the alien threat could enhance humanity's chances of

success.

Infiltration and Espionage: Sending undercover operatives to gather intelligence, disrupt alien operations, and gather vital information on their capabilities and weaknesses.

Adapt and Learn: As the conflict progresses, humans might learn more about the aliens' technology, strategies, and tactics. This knowledge could be used to develop countermeasures and defensive strategies.

Diplomacy (As a Last Resort): If feasible, attempting to communicate with the alien invaders and negotiate a peaceful resolution could be a long-shot option to consider.

It's important to reiterate that the concept of hostile alien invasions is based on fictional scenarios and has no basis in established scientific understanding. In any potential interaction with extraterrestrial beings, it's crucial to prioritize peaceful communication, cooperation, and understanding. Fictional portrayals often focus on dramatic conflict, but real-world challenges would likely be far more nuanced and complex.

9 - SURVIVAL TACTICS FOR INDIVIDUAL OR SMALL GROUP

In a fictional scenario involving a hostile alien invasion, individuals or small groups would face significant challenges. While survival against technologically superior alien forces is a daunting prospect, here are some speculative survival tactics that could be considered:

Stay Informed: Monitor communication channels, news, and other sources to gather information about the aliens' movements, tactics, and vulnerabilities.

Stay Hidden: Avoid detection by finding secure hiding places in remote areas or underground. Staying out of sight could increase your chances of survival.

Gather Essential Supplies: Stock up on food,

water, medical supplies, and survival gear. These provisions will be crucial for sustaining yourself during prolonged periods of hiding.

Travel Light: Move with minimal equipment to remain agile and reduce the risk of being weighed down.

Avoid High-Traffic Areas: Stay away from populated areas and areas where alien activity is concentrated. Aliens might prioritize heavily populated regions.

Use Camouflage: Blend into your surroundings by wearing appropriate clothing and using natural materials to hide your presence.

Scout for Safe Locations: Identify hidden and defensible locations where you can seek refuge, such as caves, abandoned buildings, or remote wilderness areas.

Stay Silent: Minimize noise, as advanced alien technology could be sensitive to sound. Silence your electronic devices to avoid detection.

Stay Low-Tech: Rely on basic tools and weapons that don't rely on advanced technology, as alien

interference could disrupt electronic devices.

Form Alliances: Join forces with other survivors to pool resources, knowledge, and skills. Working together could increase your chances of survival.

Guerilla Tactics: If you encounter alien forces, employ hit-and-run tactics to disrupt their operations without direct confrontation.

Monitor Alien Movements: Observe the aliens from a distance to learn about their behavior and patterns. This knowledge could help you avoid their patrols and identify weaknesses.

Communicate Wisely: If you need to communicate with others, use secure and discreet methods to avoid detection by the aliens.

Prioritize Defense: If you're forced into a confrontation, focus on self-defense and evasion rather than direct combat. Alien technology might be vastly superior.

Adapt and Learn: Continuously adapt your tactics and strategies based on the evolving situation and the information you gather.

It's important to remember that these suggestions are purely speculative and are based on fictional scenarios. In reality, the concept of hostile alien invasions remains speculative and without credible scientific basis. In any situation involving potential threats, the best approach is to prioritize personal safety, cooperation, and peaceful resolution whenever possible.

10 - SURVIVAL CHECKLIST

Survival checklist for an individual facing a hypothetical alien invasion scenario. Remember that this is a speculative exercise and not based on real-world events. Prioritizing peaceful resolution and cooperation is crucial.

Survival Checklist for Alien Invasion:

1. Information Gathering:
- Stay informed about alien activities, locations, and behavior through reliable sources.
- Monitor news, government announcements, and online forums for updates.

2. Essentials:
- Stock up on non-perishable food items and clean water for an extended period.
- Prepare a first aid kit with essential medical

supplies.
- Gather basic tools like a multi-tool, flashlight, and fire-starting equipment.
- Pack clothing suitable for the climate and camouflage if needed.

3. Communication:
- Have a battery-powered or hand-crank emergency radio to stay connected to news updates.
- Use encrypted messaging apps or short-range communication devices to coordinate with allies.

4. Hide and Evade:
- Identify remote, hidden locations where you can take shelter.
- Create concealed shelters or hide in natural formations like caves, dense forests, or abandoned structures.

5. Movement:
- Travel light to remain agile and conserve energy.
- Plan escape routes and avoid high-traffic areas, staying away from major roads and populated centers.

6. Camouflage and Concealment:
- Wear clothing that blends in with the environment and minimizes visibility.
- Use natural materials to create cover for your shelter.

7. Security:
- Set up basic early warning systems such as tripwires or noise-making devices.
- Stay vigilant and alert to changes in the environment.

8. Gather Intelligence:
- Observe alien movements from a safe distance to learn about their behavior and patterns.

9. Self-Defense:
- Have a basic self-defense plan in case of close encounters.
- A usable captured alien weapon would be the best weapon in hand. Otherwise, guns or any projectile hurling weapons should be prioritize before any melee type weapons.

10. Cooperation:
- Form alliances with trustworthy individuals to share resources, knowledge, and skills.

11. Low-Tech Approach:
- Rely on low-tech solutions and manual tools that are less likely to be affected by alien technology.

12. Long-Term Survival:
- Learn basic survival skills like foraging for food, purifying water, and basic medical care.

- Develop strategies for long-term survival, including renewable food sources and sustainable living.

13. Mental Resilience:
- Maintain a positive mindset and stay mentally resilient in the face of stress and uncertainty.

Remember that the primary focus should be on peaceful resolution, cooperation, and understanding. While this checklist provides speculative guidelines, the importance of real-world safety and preparedness cannot be emphasized enough.

14. Survival Gear Checklist for Hypothetical Alien Invasion:

(a) Shelter and Protection:
- Portable tent or tarp for creating shelter.
- Sleeping bag or lightweight bedding for comfort and warmth.
- Personal body armor or protective clothing for defense against potential threats.

(b) Survival Tools:
- Multi-tool with various functions (knife, pliers, screwdriver, etc.).
- Compact folding shovel for digging and creating barriers.
- Fire-starting kit (waterproof matches, fire starter, lighter).

A multi-tool is a versatile gadget that combines various functions in one compact package. It typically includes features like a knife, pliers, screwdriver, can opener, and more. This tool proves invaluable for tasks such as cutting, repairing equipment, opening cans, and manipulating objects.

(c) **Navigation and Communication:**
- Hand-crank emergency radio for receiving news and updates.
- Whistle for signaling and alerting others to your presence.
- Compass for navigation without relying on electronic devices.

A hand-crank emergency radio doesn't rely on batteries or external power sources. By cranking the handle, you generate the energy needed to power the radio, allowing you to receive news updates, weather forecasts, and emergency alerts even in situations where electricity is unavailable.

(d) **Food and Water:**
- Non-perishable food items (canned goods, energy bars, dehydrated meals).
- Portable water filtration system or water purification tablets.

A portable water filtration system or purification tablets enable you to convert potentially unsafe water sources into drinkable water. Ensuring a clean water supply is vital for hydration and preventing waterborne illnesses.

(e) **Medical Supplies:**

- First aid kit with bandages, antiseptics, pain relievers, and medical tools.
- Prescription medications and any necessary medical supplies.

A well-equipped first aid kit includes bandages, antiseptics, pain relievers, medical tools, and more. It's crucial for treating injuries, preventing infection, and providing basic medical care in emergency situations.

(f) Clothing and Protection:
- Appropriate clothing for the climate, including layers for warmth.
- Sturdy hiking boots for mobility and protection.
- Sunglasses and headgear for sun and weather protection.

(g) Security and Defense:
- Non-lethal self-defense tools like pepper spray or baton.
- Lethal weapons such as guns or any projectile hurling weapons.
- Compact, durable flashlight for illumination and signaling.
- Emergency whistle to attract attention if

needed.

A durable flashlight with high luminosity is essential for illumination during nighttime or in dark environments. It also serves as a signaling device and can disorient potential threats if equipped with a strobe feature.

(h) **Basic Hygiene:**
- Personal hygiene items (toothbrush, toothpaste, soap, etc.).
- Hand sanitizer or antibacterial wipes for cleanliness.

(i) **Navigation and Orientation:**
- Detailed maps of your area and nearby terrain.
- Pen and paper for notes, mapping, and communication.

(j) **Miscellaneous:**
- Compact binoculars for observing distant objects and potential threats.
- Spare batteries for essential devices.
- Cash in small denominations for emergency transactions.

Remember that personal needs and preferences may vary, so tailor this checklist to suit your individual

circumstances. Additionally, while preparation is important, the primary focus should be on peaceful resolution and cooperation in any potential encounter with extraterrestrial beings.

11 - SHTF

In a scenario of a global alien invasion, commonly referred to as a "SHTF" (Sh*t Hits The Fan) situation, the challenges extend beyond just facing the extraterrestrial threat. As resources become scarcer and tensions rise, conflicts among humans become a significant concern. In such a dire situation, survival instincts can lead to competition for limited resources like food, water, shelter, and medical supplies. It's crucial to anticipate and address these challenges to minimize conflicts and promote cooperation among survivors.

Scenario: Resource Depletion and Conflict Among Humans

As the alien invasion disrupts societal structures and access to resources, scarcity becomes a pressing issue. Basic necessities like food, water, and medical supplies dwindle, creating a sense of desperation among survivors. This scarcity, combined with fear

of the alien threat, leads to heightened stress levels and potential conflict. Competing groups or individuals might clash over limited resources, leading to violence and further destabilization.

Mitigation and Solutions:

Establish Communication Channels: Prioritize open and effective communication among survivors. Establish a system for sharing information about resource availability, potential threats, and survival strategies. This can reduce misunderstandings and promote collaboration.

Form Alliances: Encourage the formation of alliances or community groups. Cooperative efforts allow for resource pooling, sharing skills, and supporting one another during times of scarcity. Strong communities are better equipped to manage conflicts.

Resource Management: Implement a fair and transparent resource management system. Develop guidelines for rationing resources based on need, ensuring that everyone has access to essential supplies.

Distribution Centers: Establish distribution

centers where available resources are equitably distributed to those in need. This prevents hoarding and ensures that no individual or group has an unfair advantage.

Conflict Resolution: Train individuals in conflict resolution and mediation techniques. Having impartial mediators can help de-escalate disputes and prevent violence from erupting.

Education and Awareness: Raise awareness about the potential consequences of conflict and the benefits of cooperation. Educate survivors about the importance of working together to overcome challenges.

Security and Defense: Collaboratively develop security measures to deter potential conflicts. A united front against external threats, such as the aliens, can shift focus away from internal conflicts.

Sustainable Practices: Emphasize sustainable practices for resource utilization, including water conservation, food cultivation, and waste reduction. This can help alleviate resource scarcity over time.

Leadership and Governance: Establish leadership structures that prioritize the common good. Leaders who prioritize fairness, transparency, and the well-being of the group can help prevent power struggles and mitigate conflicts.

Crisis Training: Provide training in crisis management and survival skills to empower individuals to handle difficult situations constructively.

In a scenario as dire as a global alien invasion, fostering a sense of community, cooperation, and shared purpose is crucial. While the hypothetical nature of such an event makes these suggestions speculative, the core principles of unity, empathy, and collaboration can guide us even in the face of the most challenging circumstances. Remember, the primary focus should always be on finding peaceful solutions and ensuring the survival and well-being of all involved.

CONCLUSION

Our journey through these discussions has been a dynamic exploration that spanned from the speculative reaches of science fiction to the practical considerations of our own reality. Starting with the intriguing prospect of alien encounters, we engaged in a thought experiment that encompassed both the awe-inspiring and the cautionary. As we traversed each topic, the boundaries between imagination and practicality blurred, revealing the intricate interplay between human ingenuity, survival instincts, and the enduring values that define us.

Alien Encounters and Survival: Speculation and Preparation

We began by delving into the speculative world of advanced extraterrestrial civilizations, contemplating their intentions and technological prowess.
Coexisting with technologically advanced aliens presents

both opportunities and challenges of unparalleled magnitude. The potential for scientific progress, cultural enrichment, and peaceful cooperation are enticing prospects. However, the risk of power imbalances, cultural clashes, ethical dilemmas, and environmental disruptions underscores the need for careful consideration and proactive strategies. In such a scenario, humanity's ability to collaborate, communicate, and find common ground would be paramount to harnessing the benefits and mitigating the drawbacks. As we contemplate the potential of sharing our world with advanced extraterrestrial beings, it is imperative that we approach this situation with humility, curiosity, and a commitment to safeguarding the interests of both Earth and the wider cosmos.

The scenario of a hostile alien invasion, though imaginative, unveiled a remarkable intersection of human adaptability and foresight. By exploring strategies ranging from staying informed about potential threats to formulating survival tactics, we acknowledged our innate capacity to strategize, plan, and adapt even in the most extraordinary circumstances.

Amid these creative scenarios, a recurrent theme emerged: unity as a linchpin for survival. The speculative backdrop prompted us to envision collective responses, emphasizing that cooperation and shared responsibility are essential when faced with unprecedented challenges. While the context was hypothetical, the principle of empathy and collaboration it underlined is a timeless truth that transcends the speculative.

Resource Management and Conflict: A Tangible Parallel

Transitioning from the speculative to the tangible, we delved into scenarios where resource depletion amid a global alien invasion instigated human conflicts. This theme paralleled real-world challenges we often encounter—competing for limited resources in times of crisis. The speculation shed light on our tendencies and illuminated the fine balance between individual needs and collective well-being.

By examining potential solutions to resource conflicts, we recognized that the same principles that guide us during conventional crises remain invaluable. Strategies like communication, cooperation, and equitable distribution of resources serve as bridges between the hypothetical and the real. This exploration demonstrated that while the setting may be otherworldly, the values we uphold—fairness, compassion, and cooperation—are universal.

Survival Tactics and Diplomacy: A Duality of Approaches

Our focus then shifted to the practical realm, exploring survival tactics individuals and groups could employ during an alien invasion. Through camouflage, intelligence-gathering, and cooperation, we highlighted the intricate web of skills that contribute to enduring challenges. Though framed in a speculative context, these tactics showcased our ability to confront the unknown with practical strategies.

Yet, amid the realm of tactics, we introduced an entirely distinct avenue—diplomacy with advanced aliens. Here, the speculative delved into uncharted territory, inviting us to ponder the complexities of interstellar communication, cultural exchange, and the spirit of collaboration. This dual approach—survival tactics and diplomatic endeavors—underscores the multifaceted nature of our responses, encompassing not only our practical skills but also our capacity for understanding and engagement.

Advanced aliens could potentially utilize their technological abilities to trigger natural disasters or manipulate human religious beliefs for their benefit.

Stepping into the realm of hostile intentions, it is very much possible that these extraterrestrial beings could engineer catastrophic events while masking their interventions under the guise of natural occurrences.

We also speculated on how advanced aliens could exploit human religious beliefs for their own gain. We contemplated scenarios where extraterrestrial beings manipulate faith and spirituality to exert control, induce compliance, and sow discord among human societies. In this chilling exploration, we saw the potential for deceptive revelations, cultural assimilation, psychological exploitation, and the strategic use of religious narratives to further their sinister agenda.

Unity, Empathy, and Collective Wisdom

As we navigated through these diverse topics, we consistently encountered threads that united them all: the importance of unity, empathy, and cooperation. Whether surviving an alien threat, managing resources, or envisioning diplomatic relations, the underlying principles of humanity's shared values emerged as a guiding light.

While the scenarios were speculative, they provided a canvas to contemplate our strengths, adaptability, and the potential pitfalls that come with them. The narratives underscored that in the face of adversity, our ability to come together, to extend compassion, and to communicate across divides serves as a beacon of hope. In a world where reality and imagination often intertwine, these discussions remind us that even in the uncharted, our shared humanity endures.

Carrying Forward the Lessons of Exploration

As we conclude this captivating journey, let us carry forward the wisdom that we've gathered—a wisdom that is both speculative and practical, imaginative and rooted in experience. In contemplating extraterrestrial encounters, survival strategies, resource management, and diplomacy, we find ourselves better equipped to face challenges that lie ahead. Our shared values—the building blocks of unity, empathy, and cooperation—are not only integral to navigating the unknown but also the very essence of what it means to be human.

From the fertile landscapes of speculation to the solid grounds of reality, we traverse with renewed understanding. As the chapters of this dialogue close, we open the pages of the unwritten future, guided by the reflections, insights, and lessons learned from our explorations. In unity and empathy, we find strength; in speculation and pragmatism, we discover the tools to thrive in a world that is both known and unknown.

ABOUT THE AUTHOR

A blogger since 2014, and avid explorer of UFO/UAP phenomena, I'm a multifaceted creator. My blogs fuse technical expertise and life experience. I'm equally at home crafting intricate electro-mechanical projects and delving into life's mysteries. As a prepper and survivalist, I thrive on preparedness.

www.ingramcontent.com/pod-product-compliance
Lightning Source LLC
Chambersburg PA
CBHW051331220526
45468CB00004B/1591